40 Mandalas Coloring Book

by Angela Ronk

Created by Angela Ronk DBA
TechneGraphix Graphic Design
www.TechneGraphix.com
Email: TechneGraphix@Gmail.com

© 2016 Angela Ronk

Published by CreateSpace August 24, 2016

ALL RIGHTS RESERVED BY ANGELA RONK

DO NOT DUPLICATE

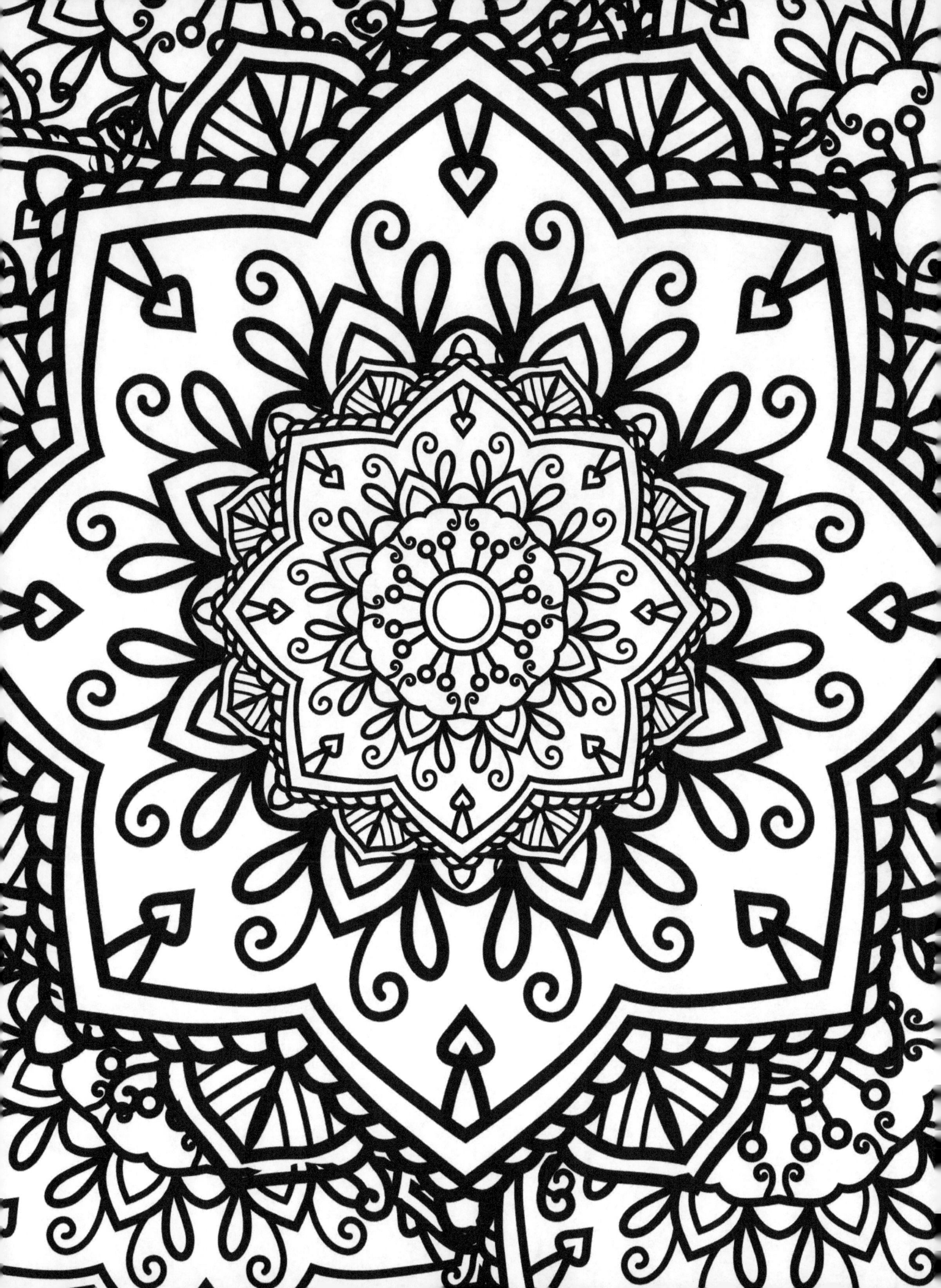

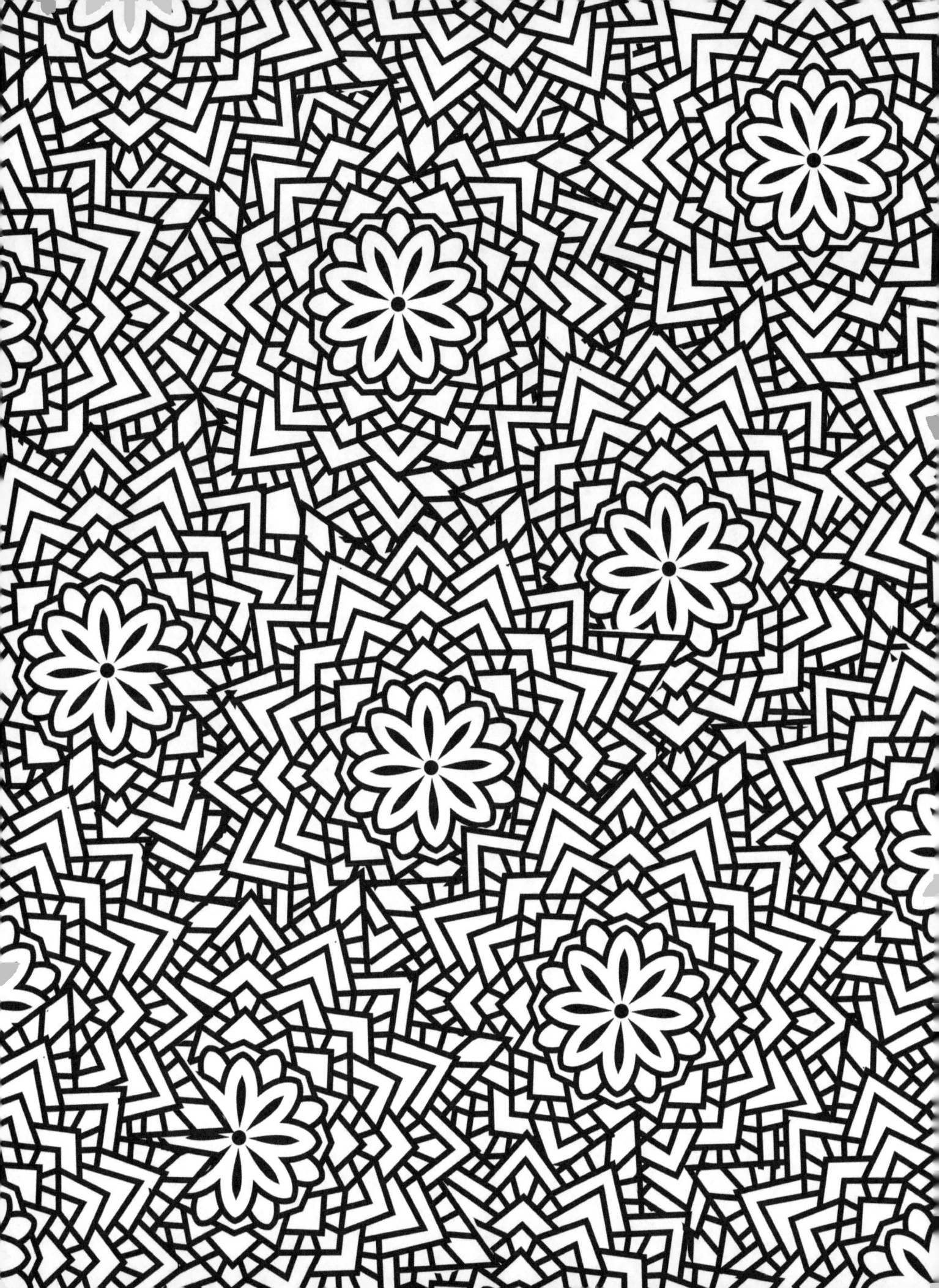

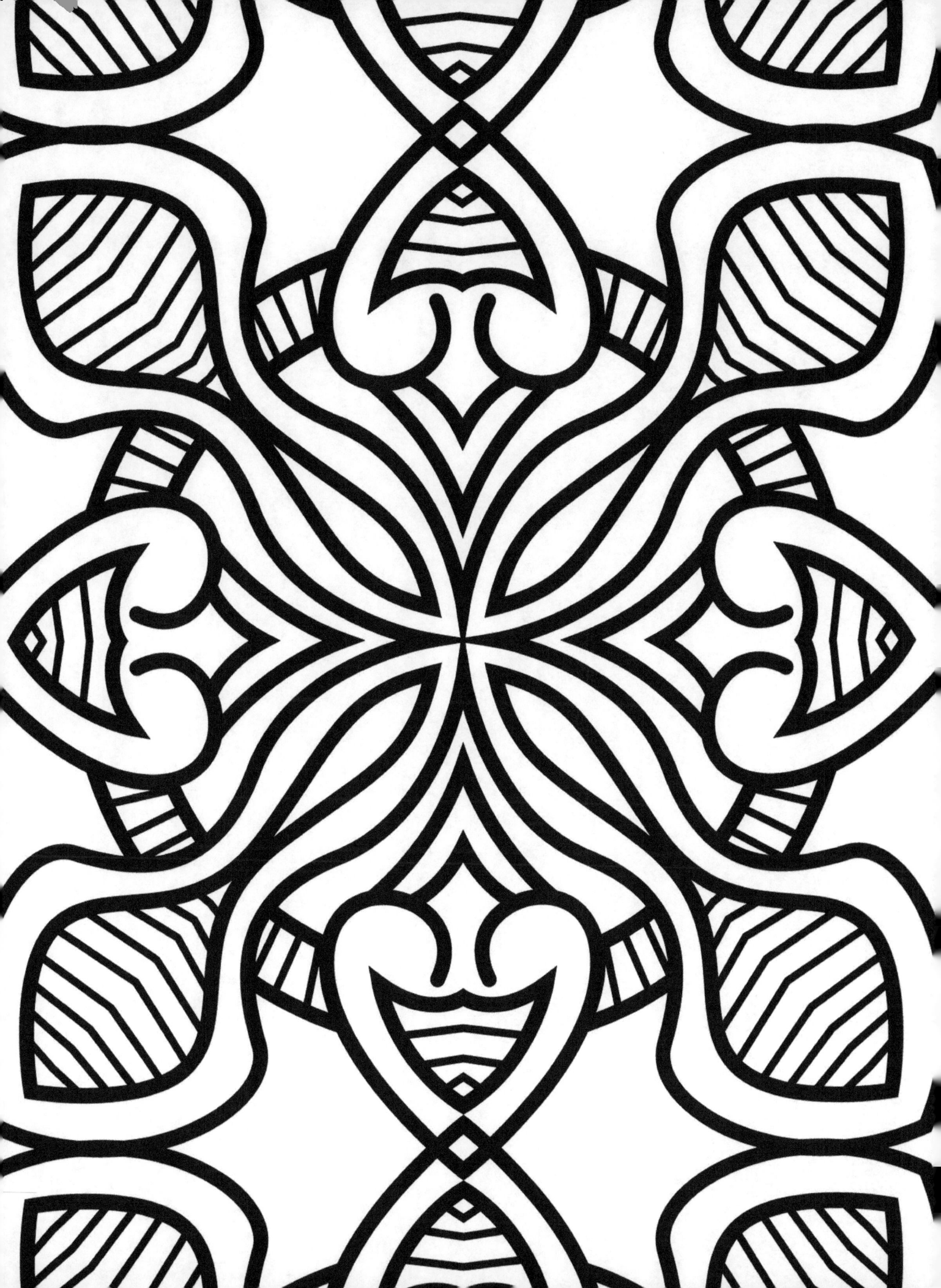

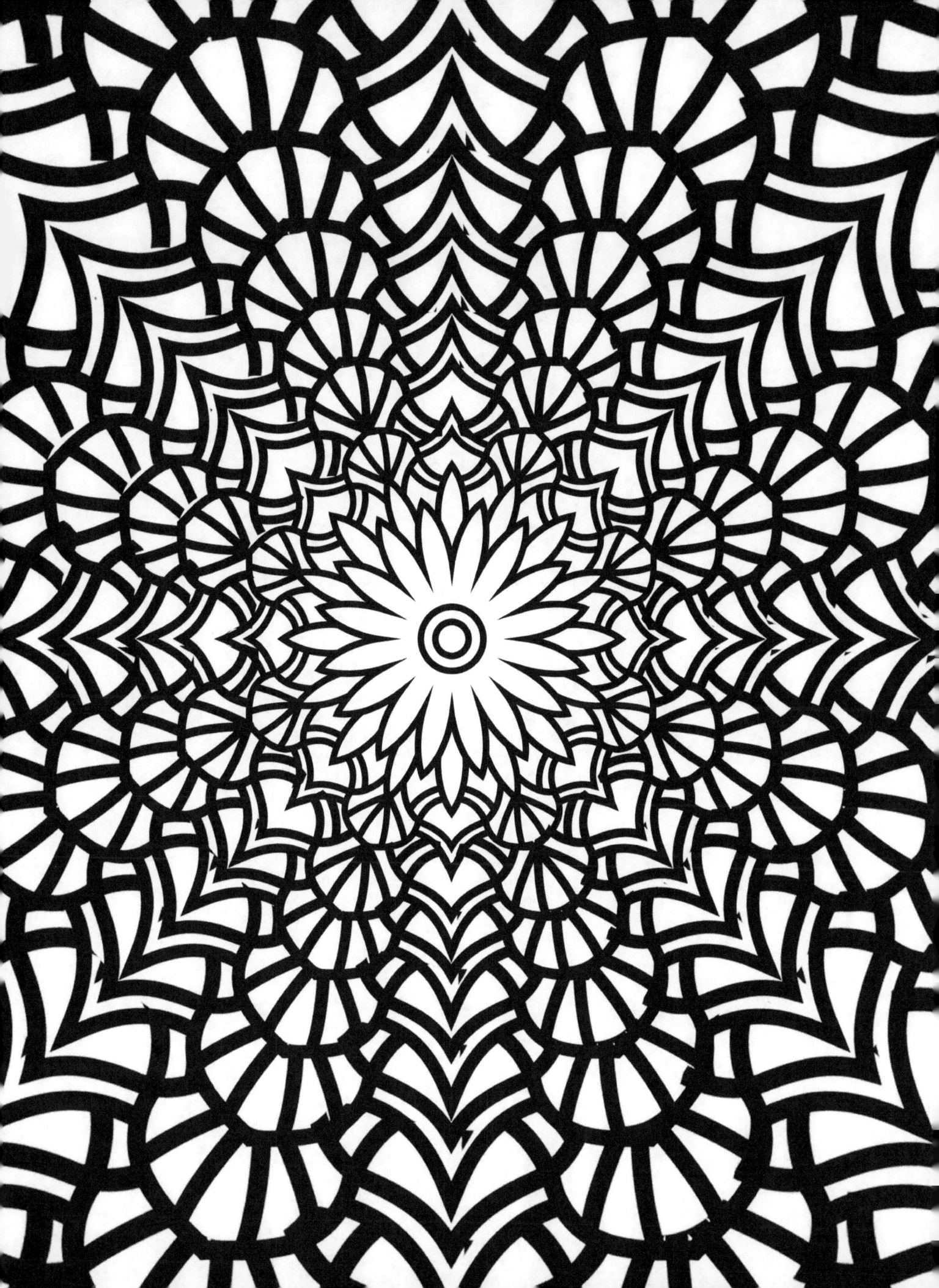

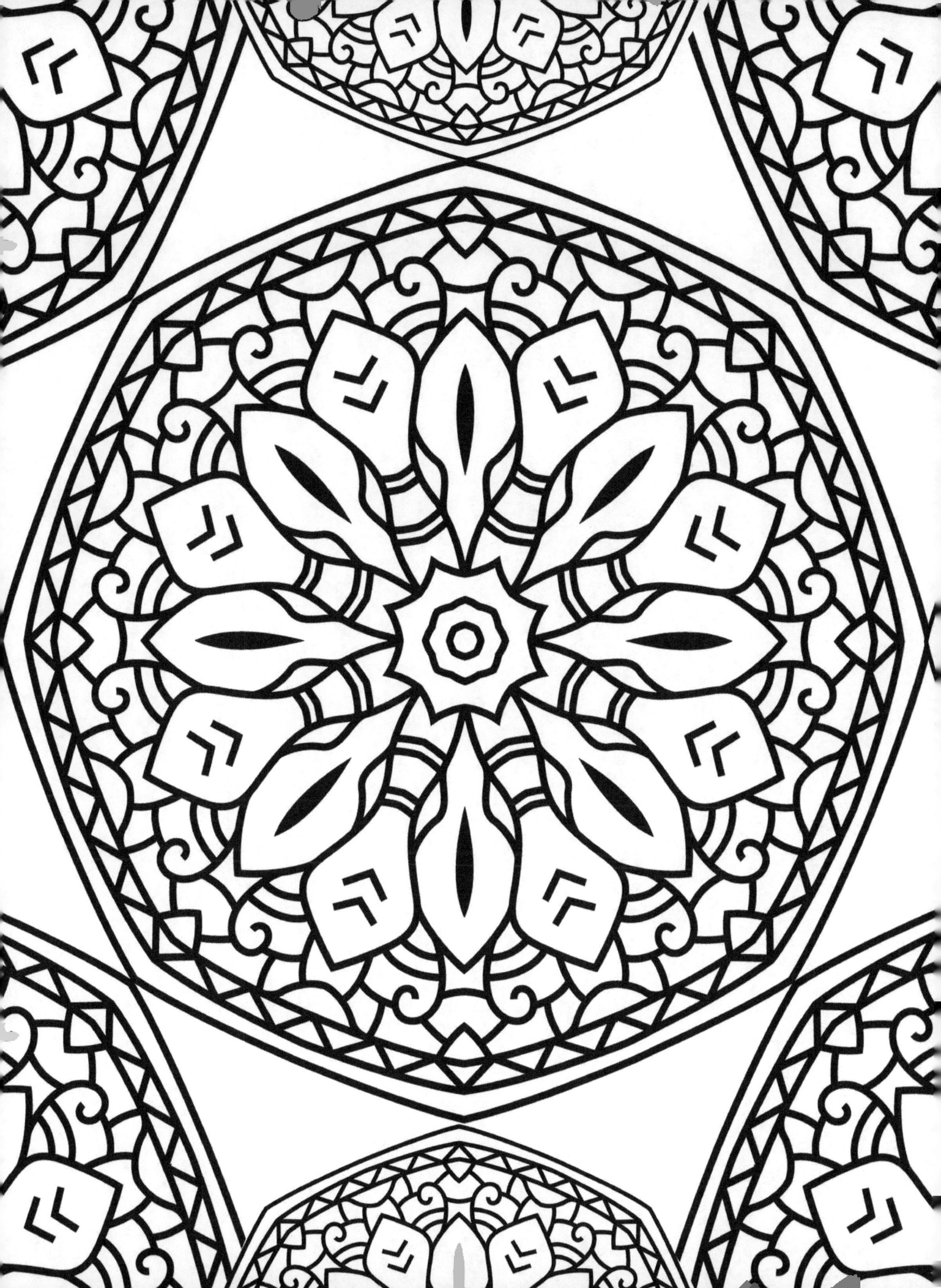

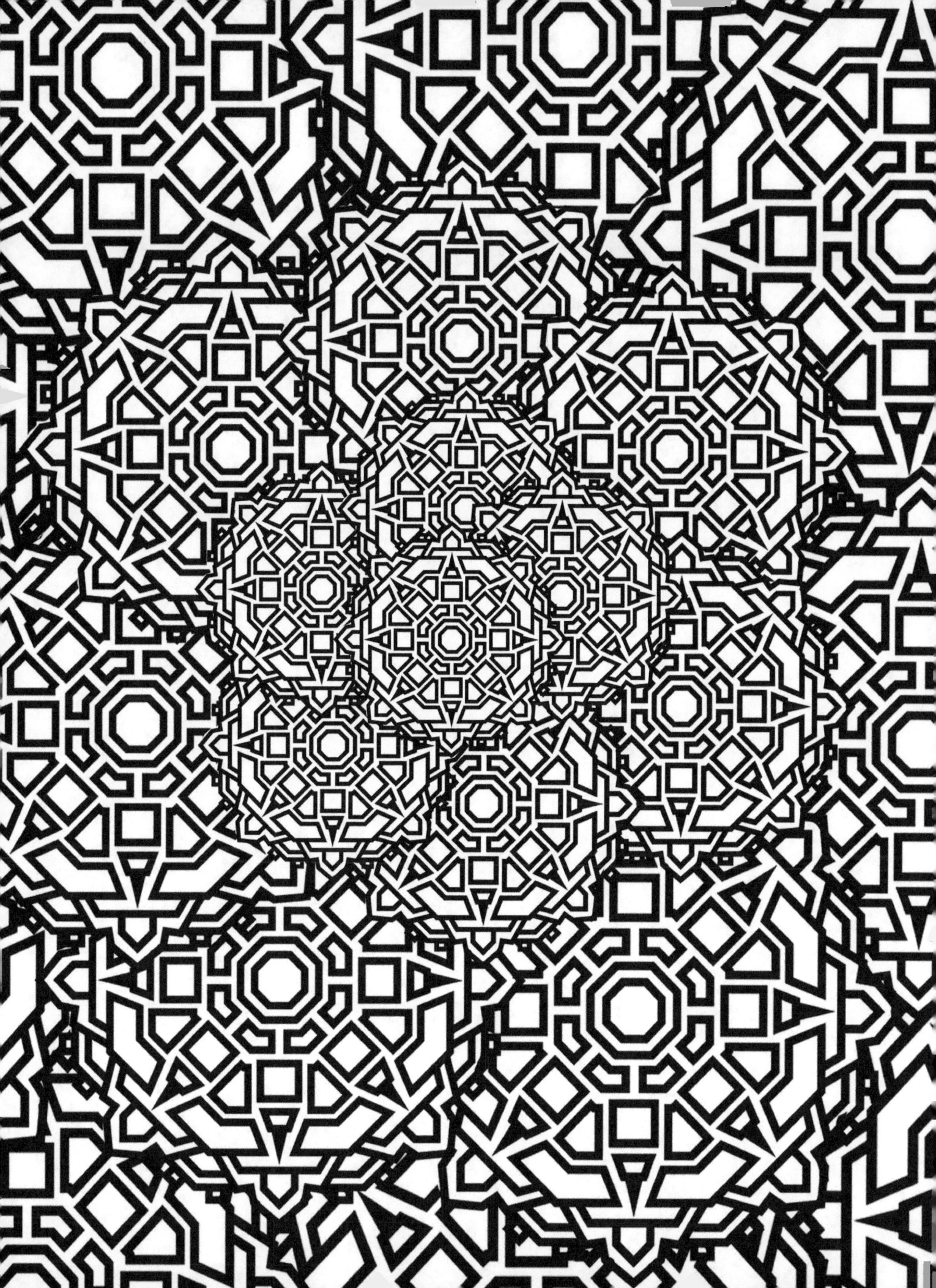

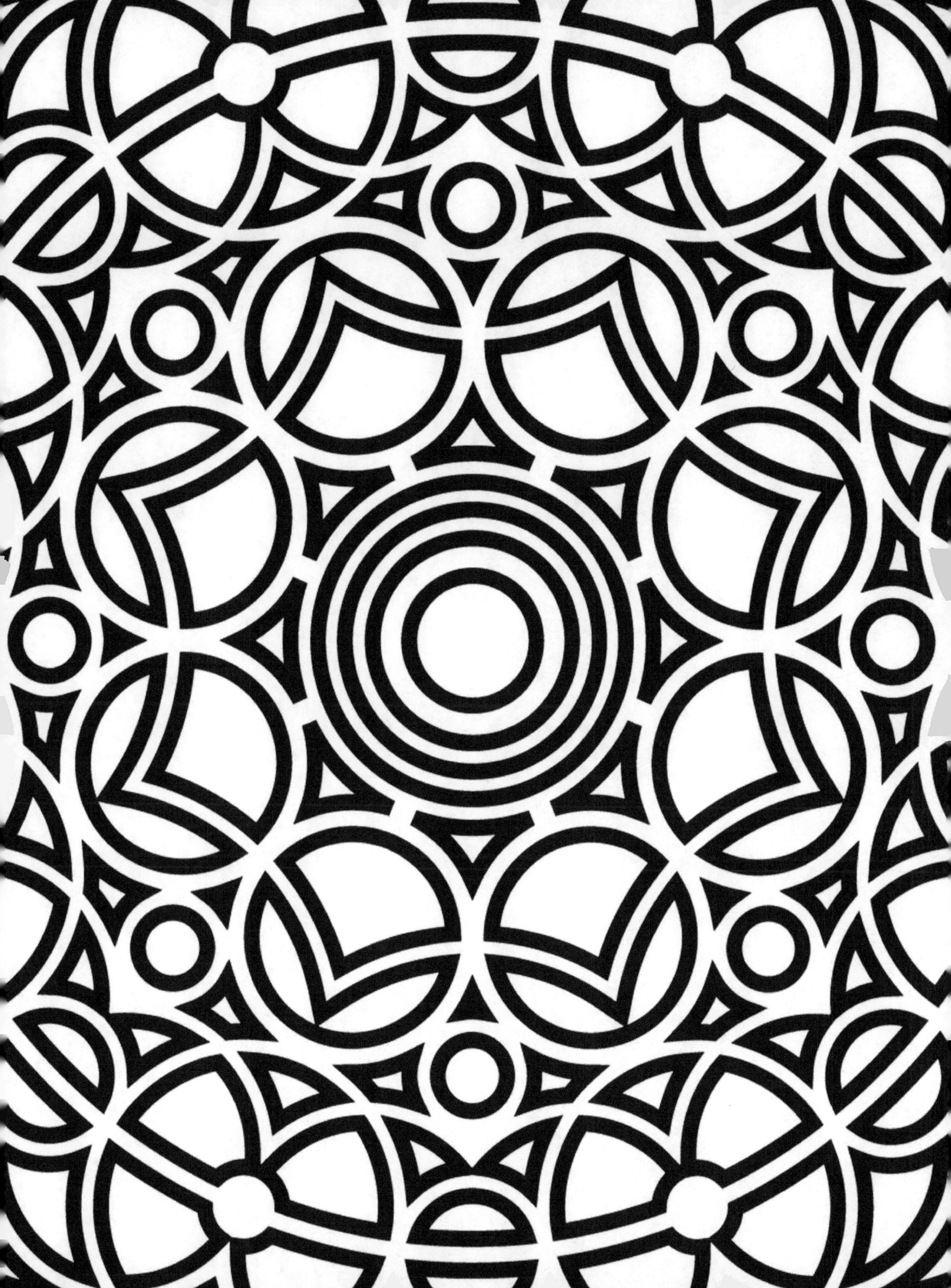

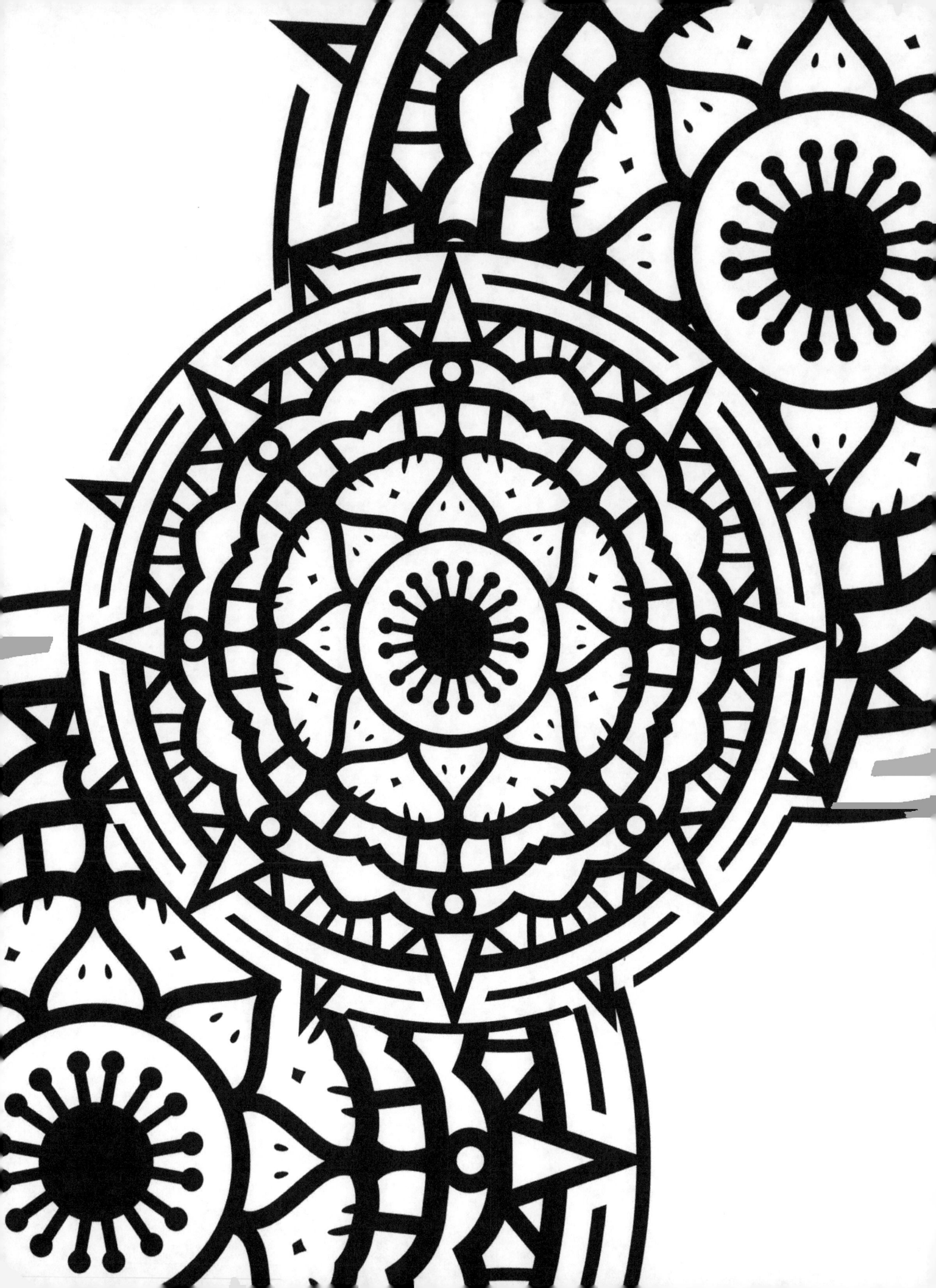

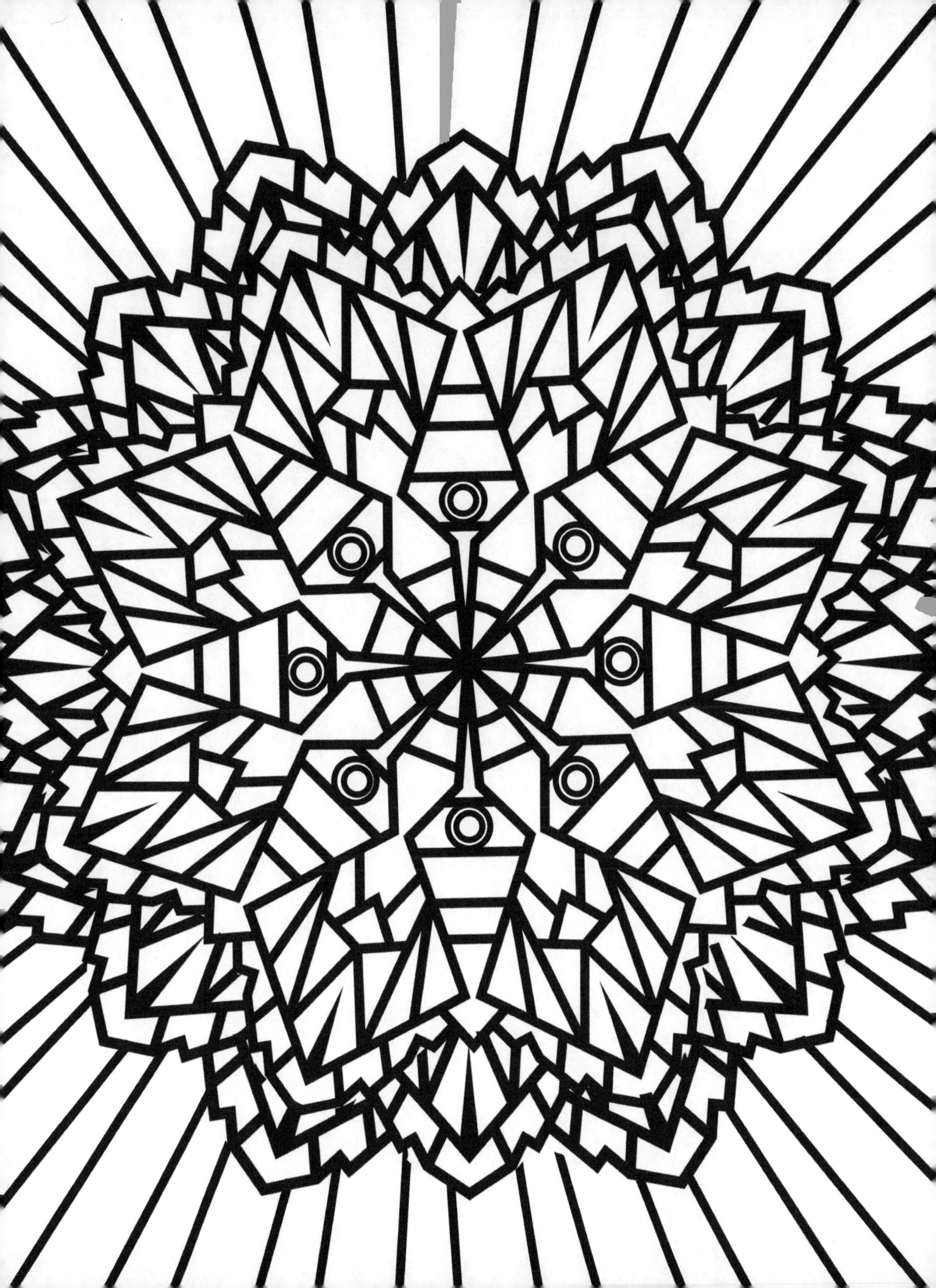

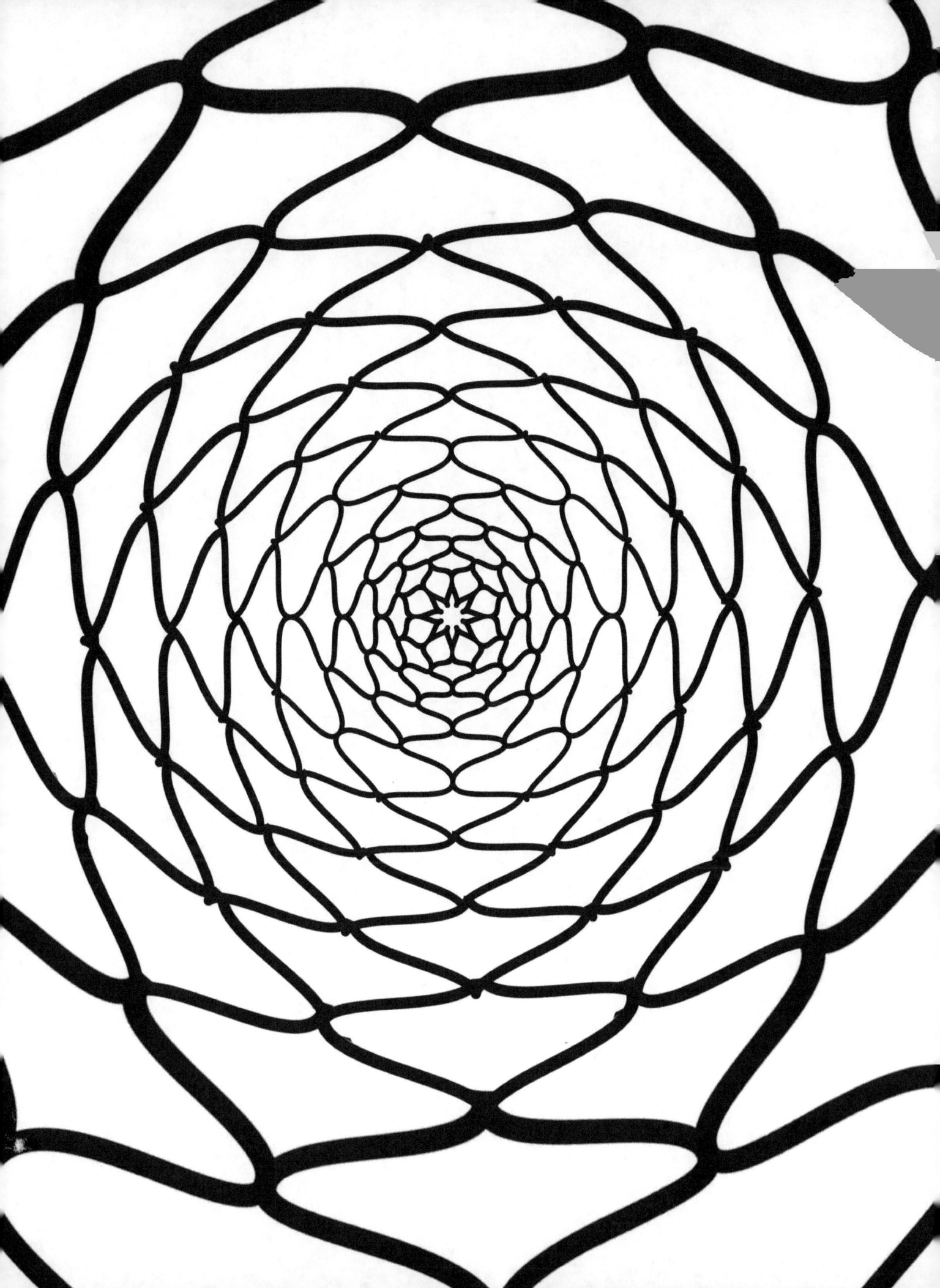

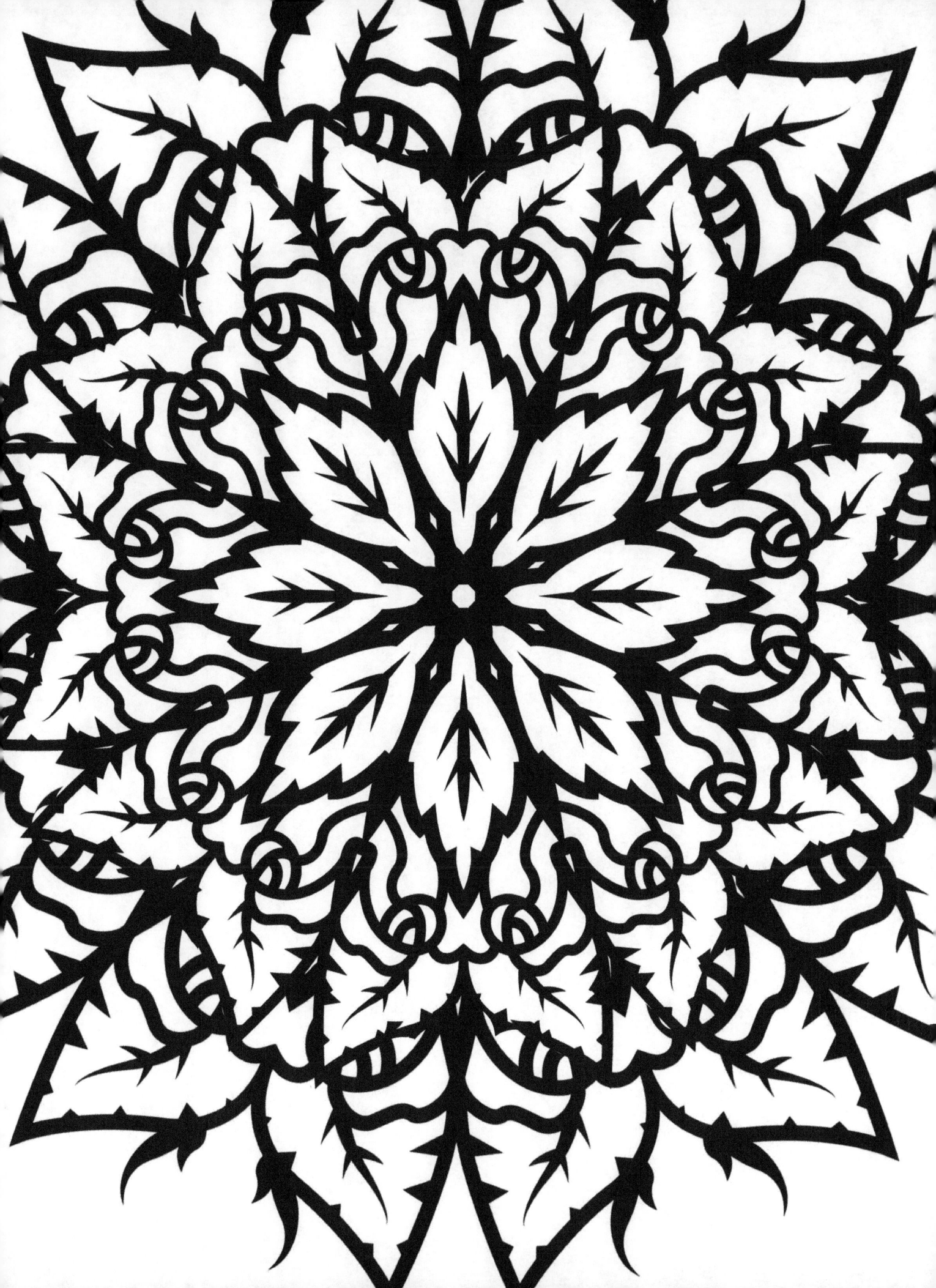

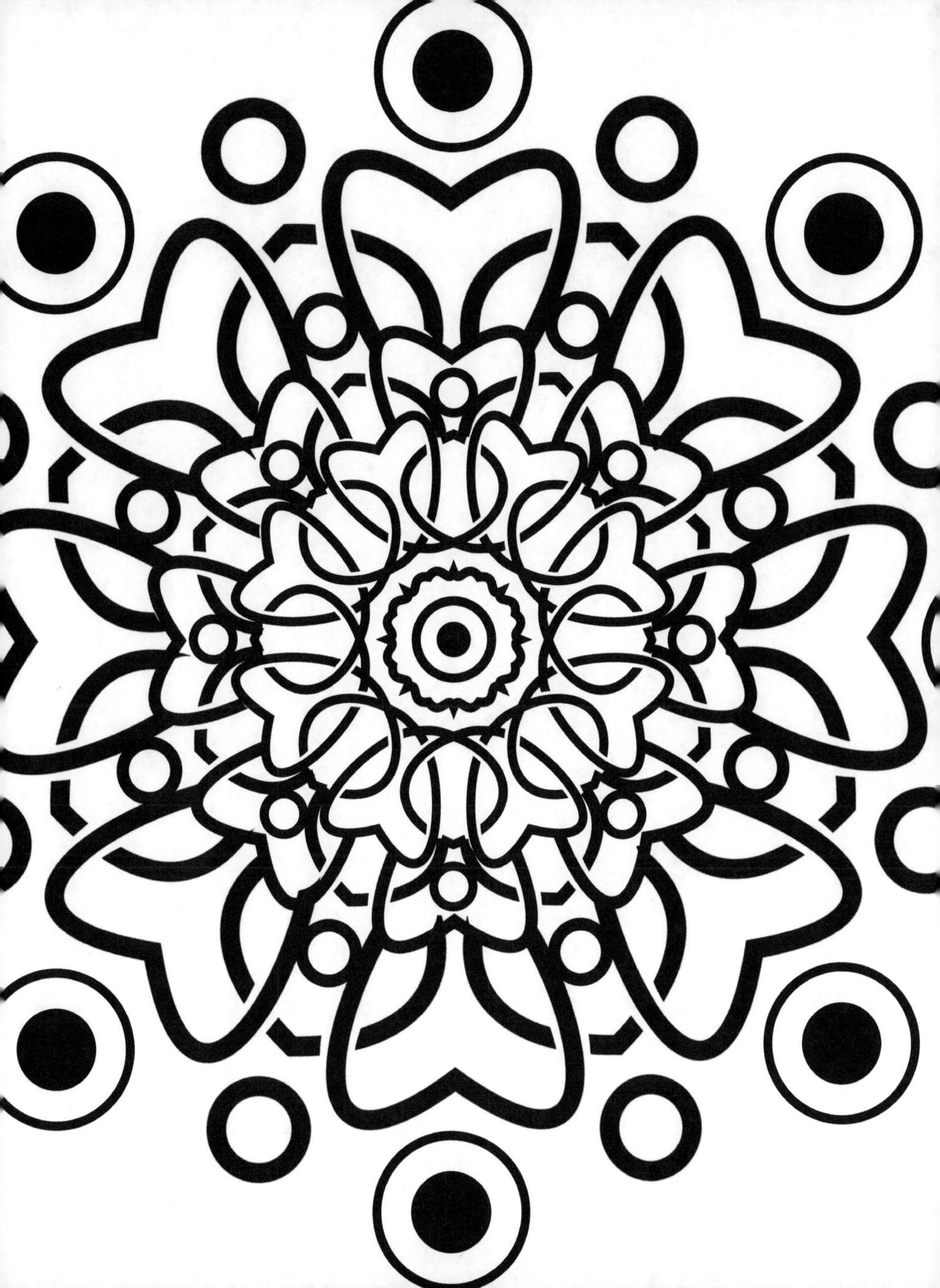

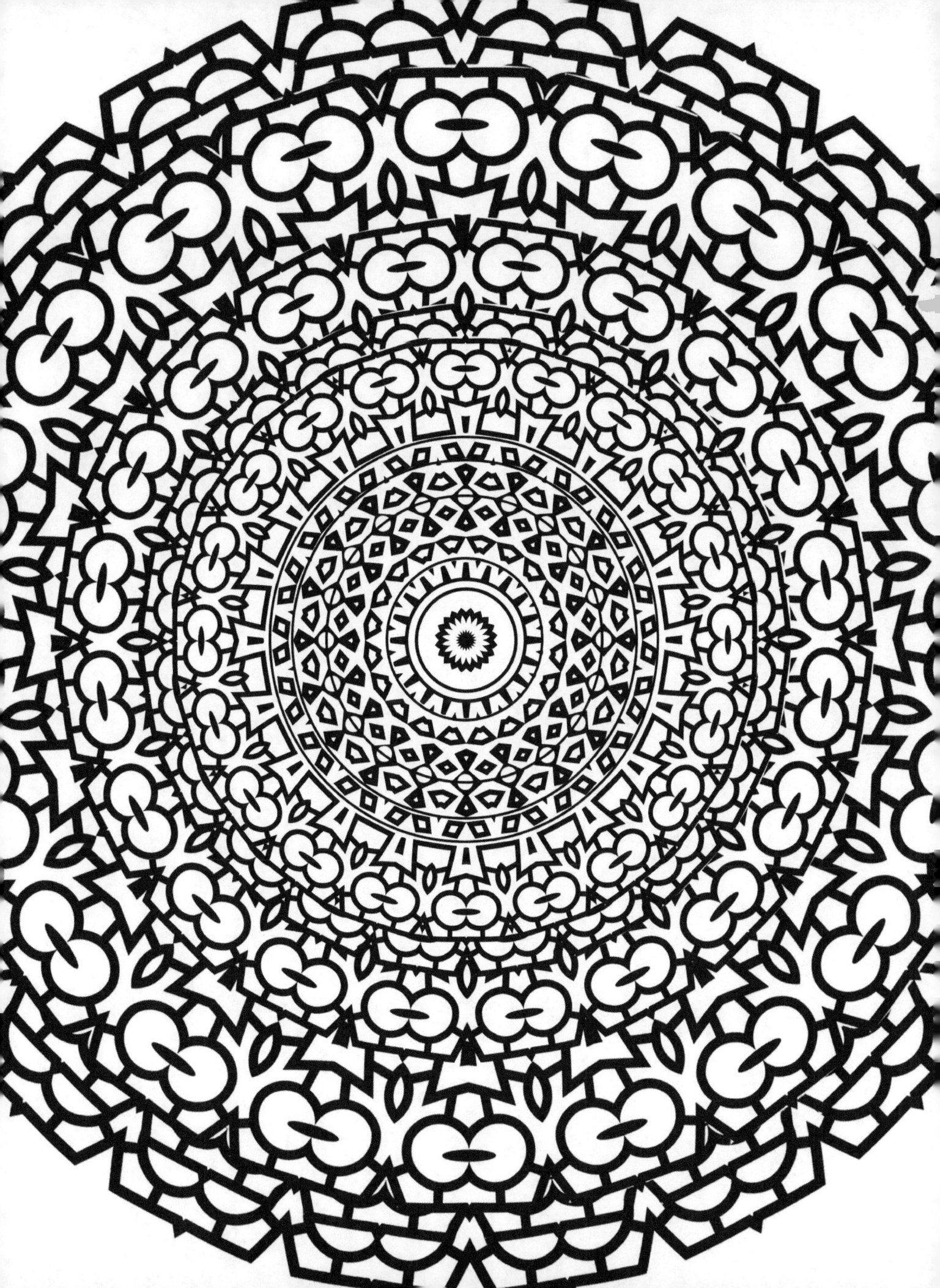

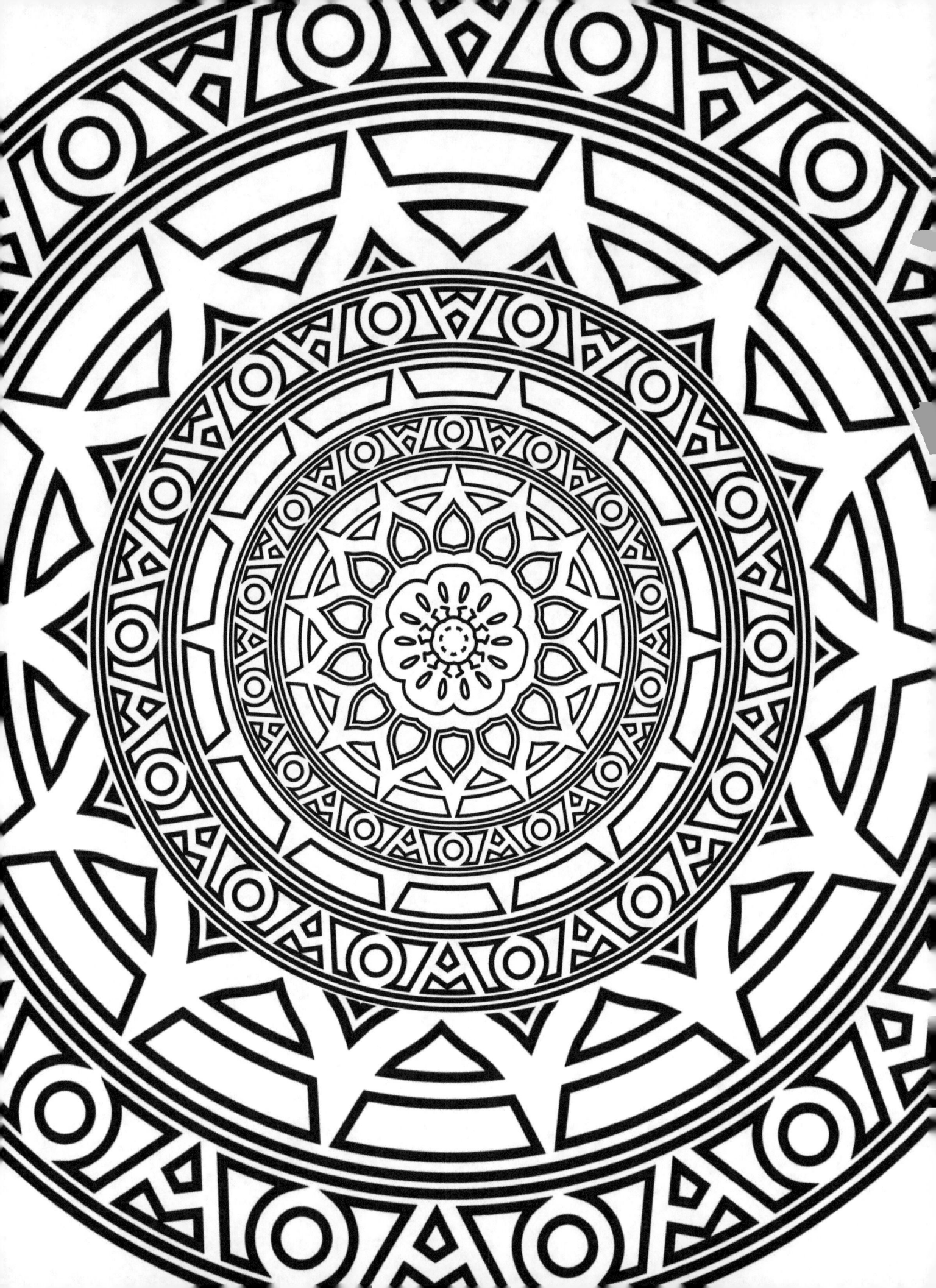

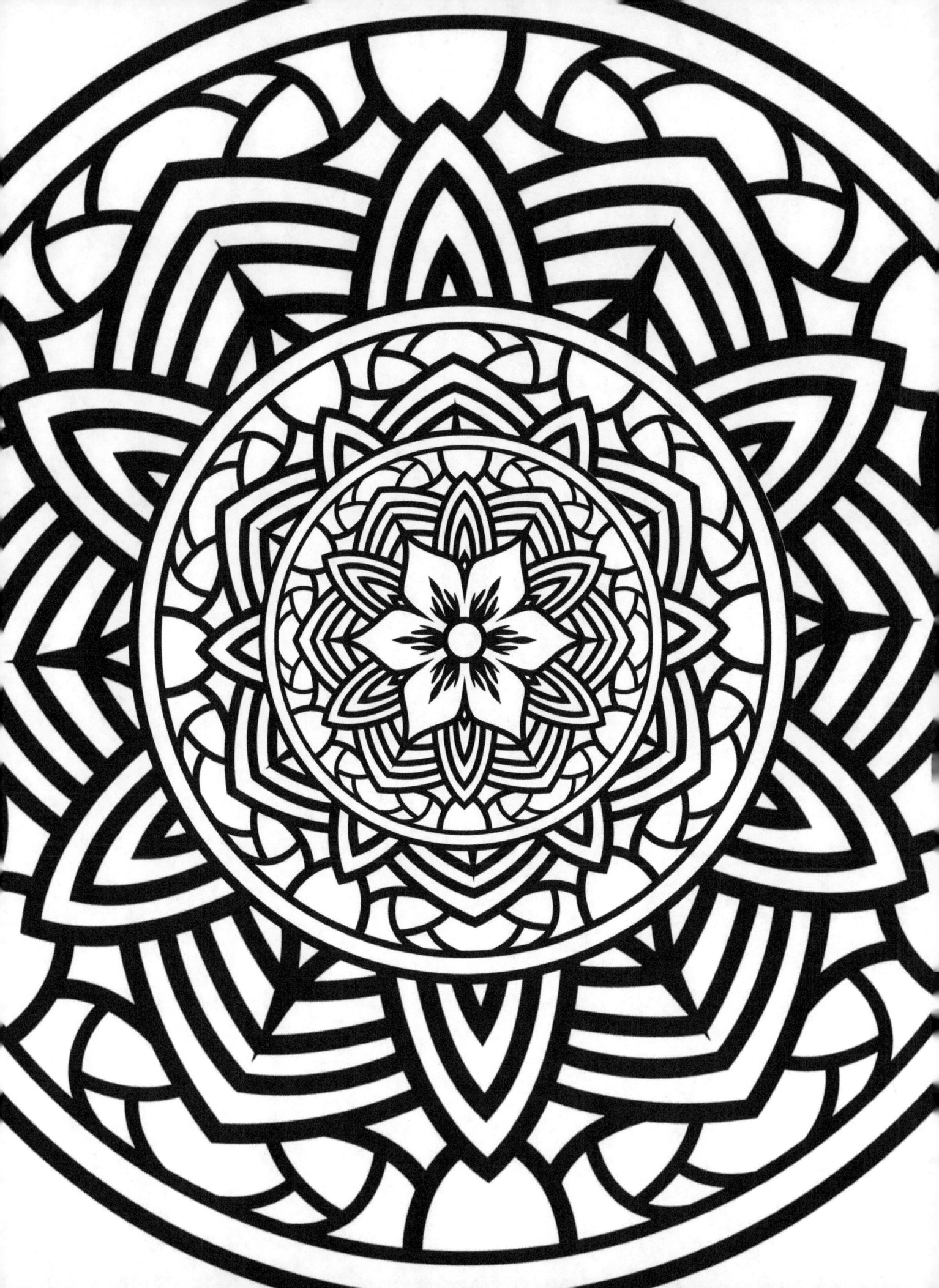

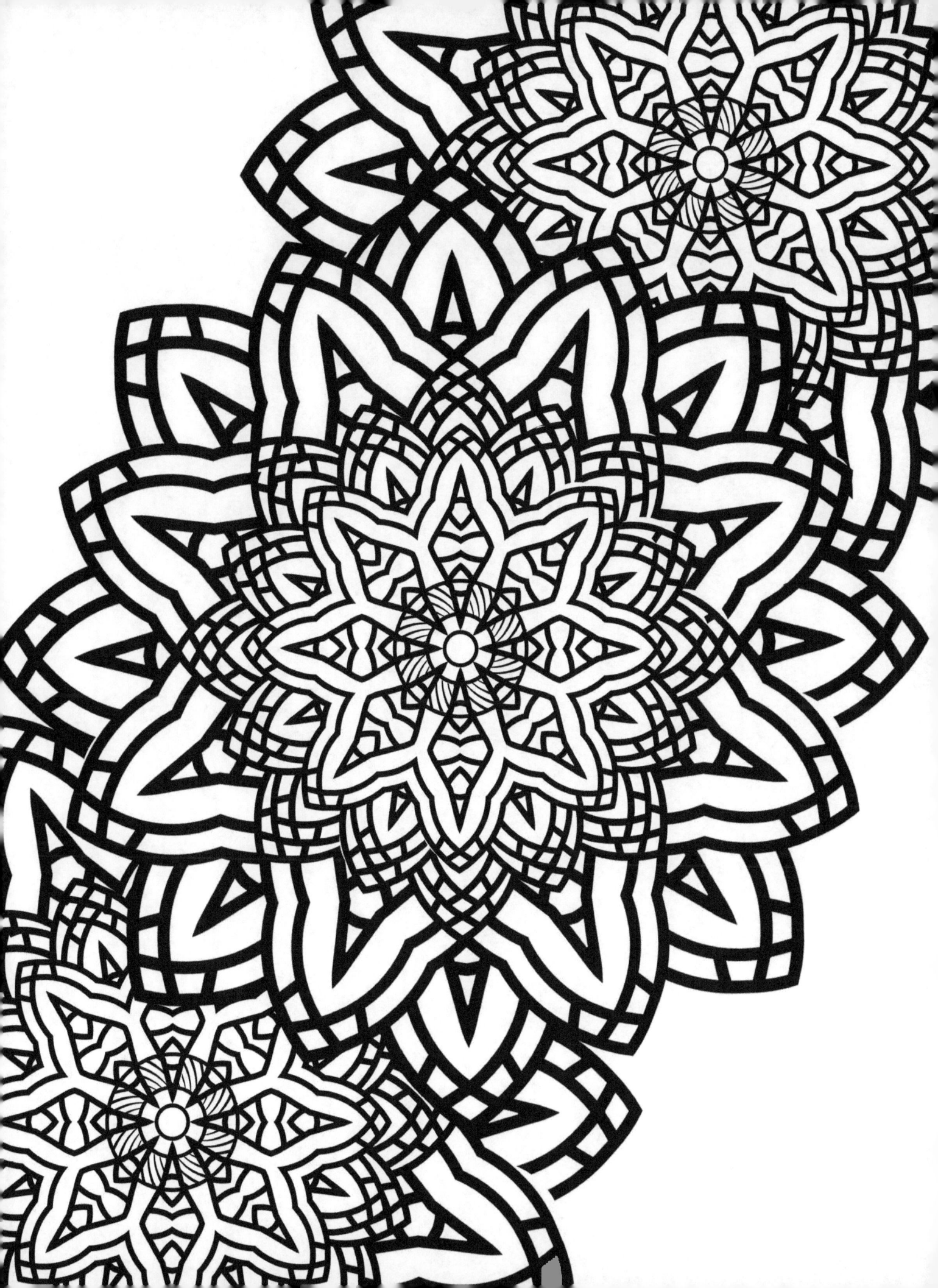

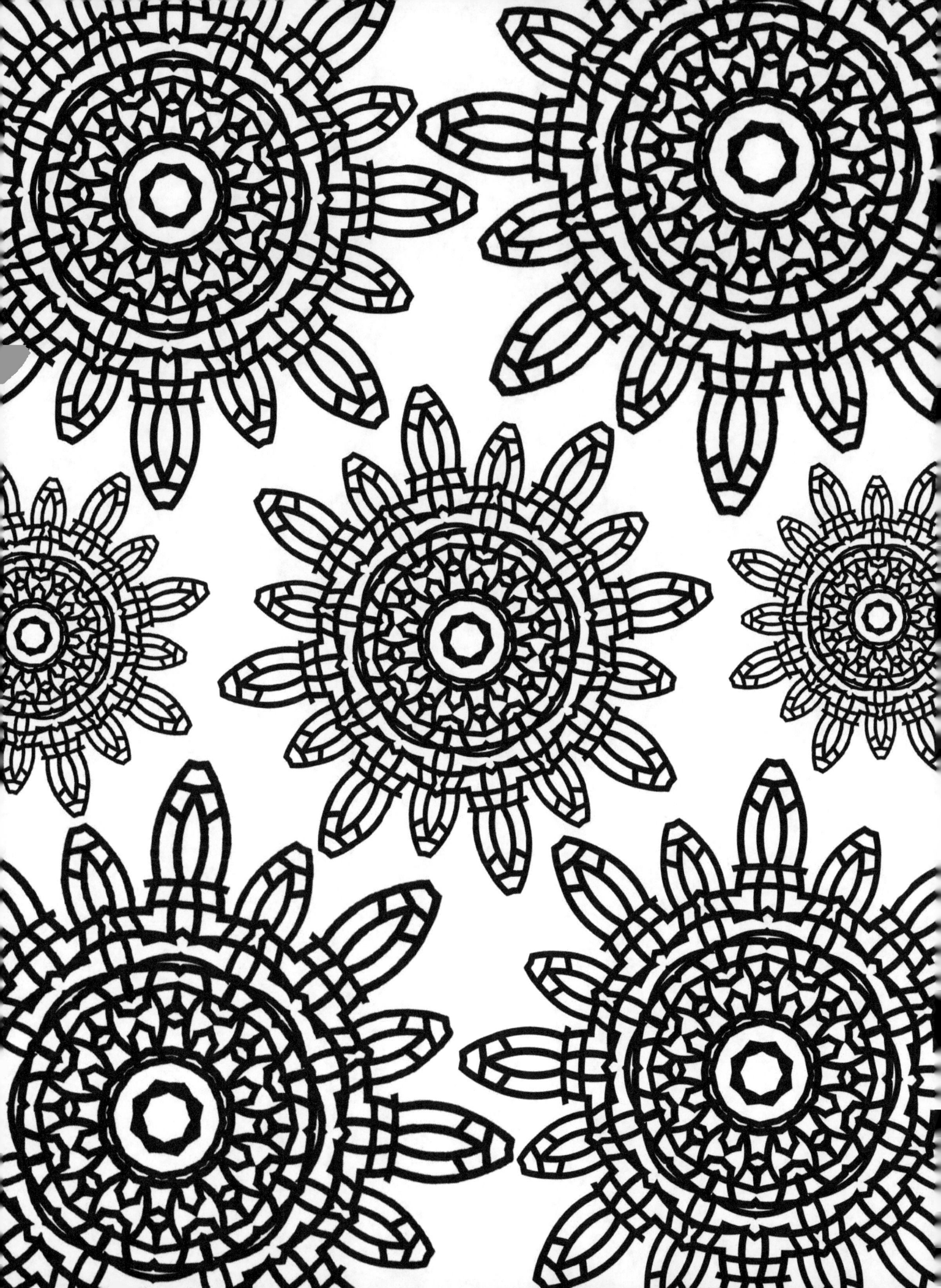

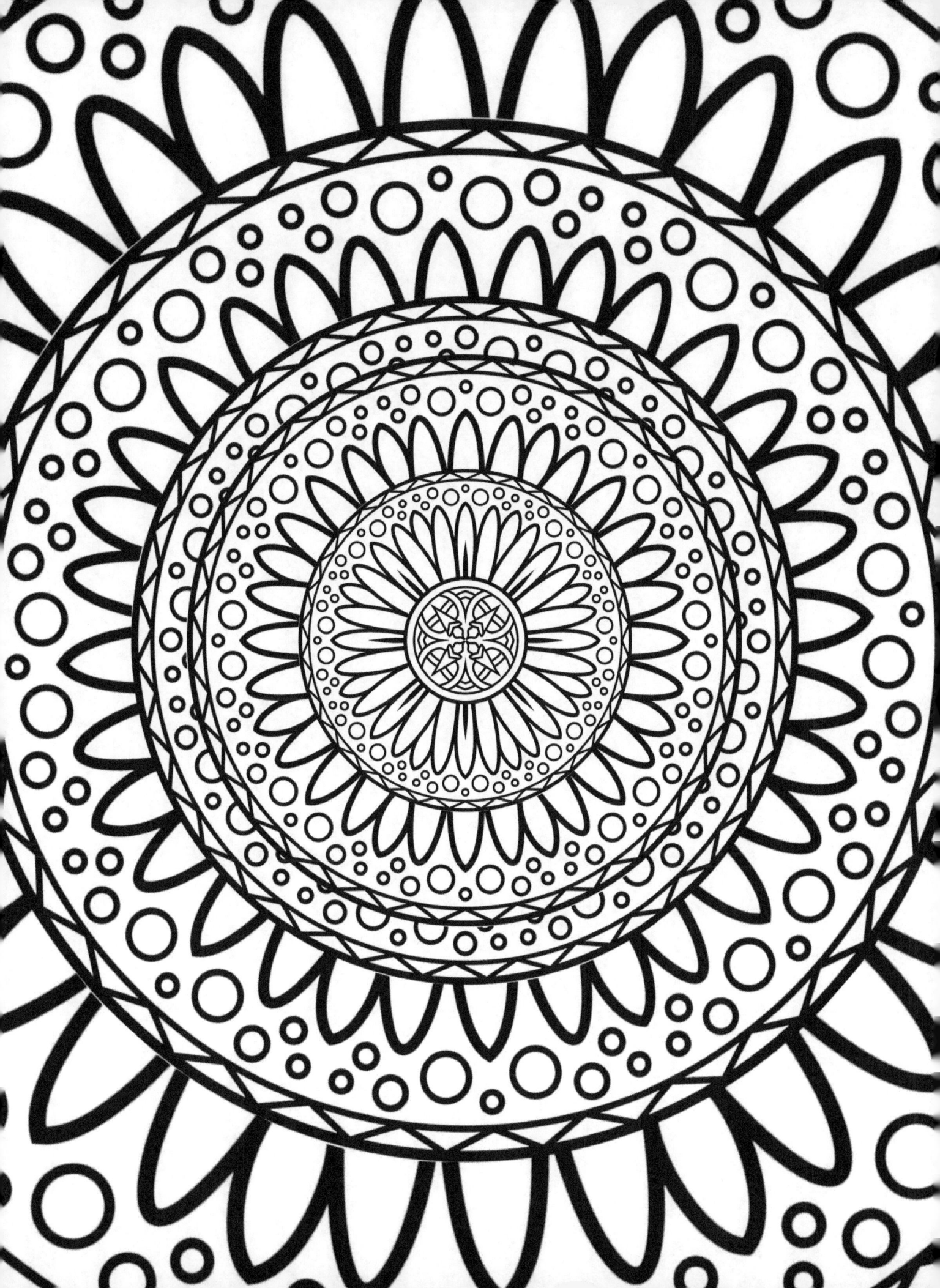

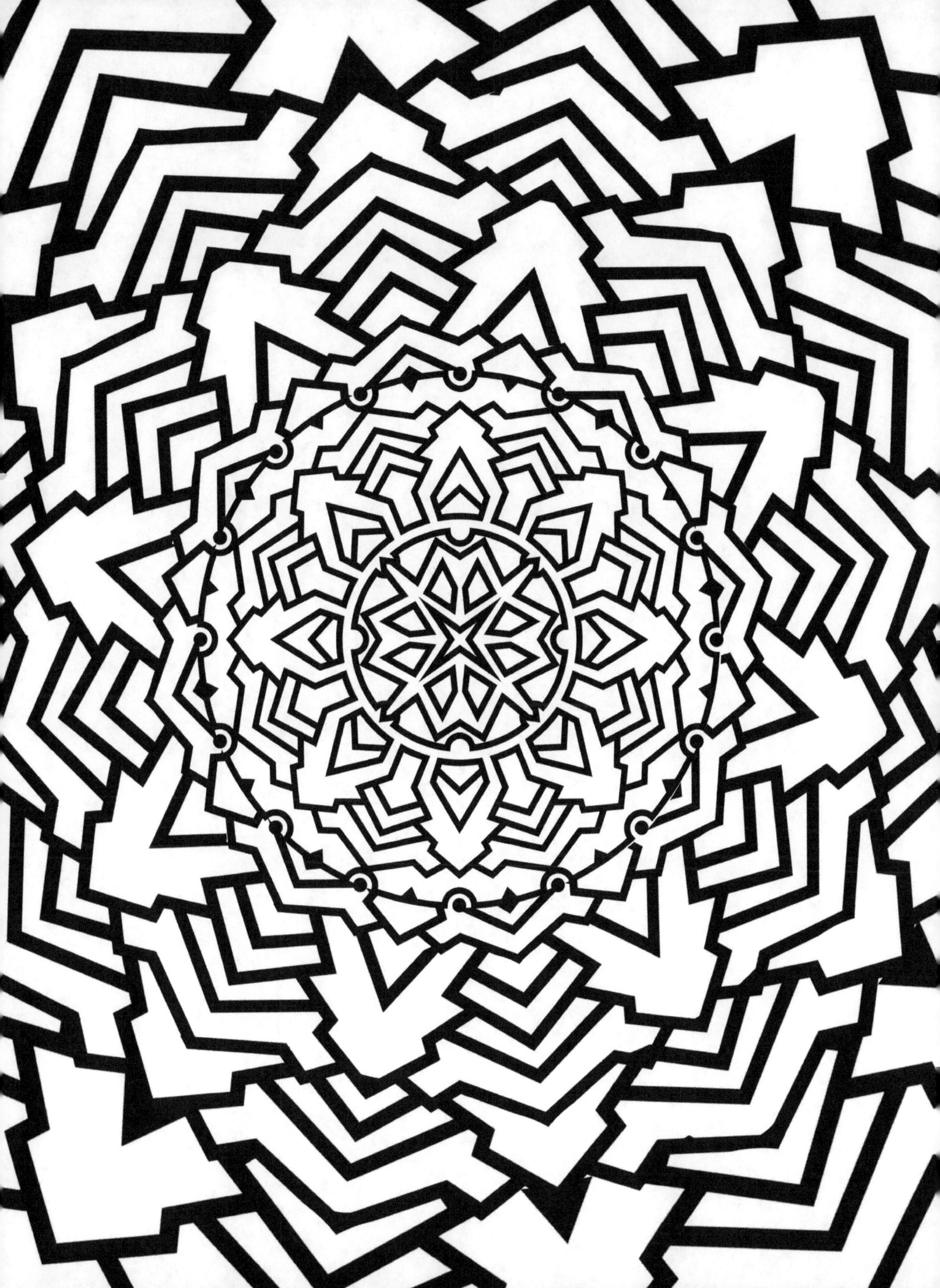

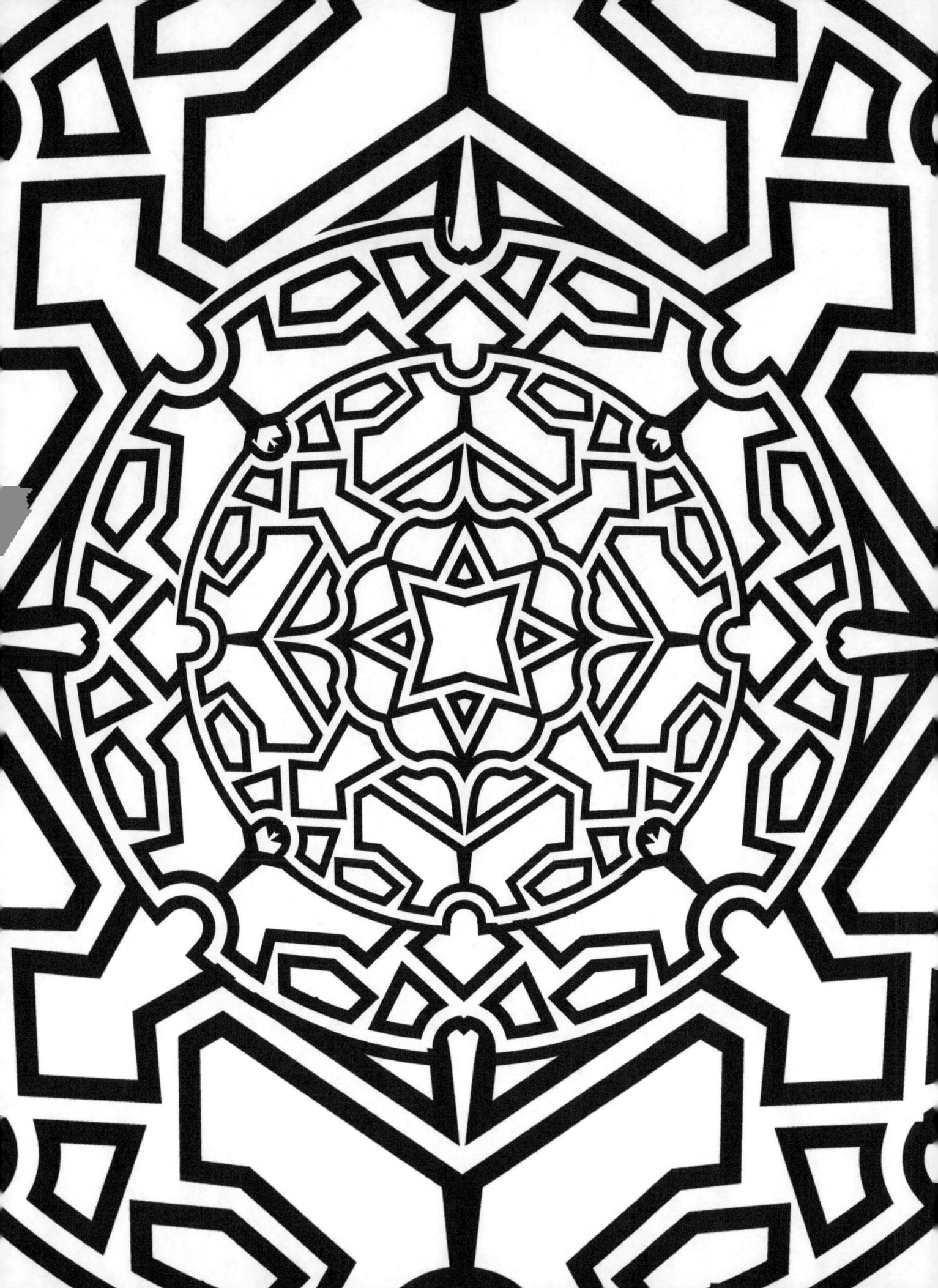

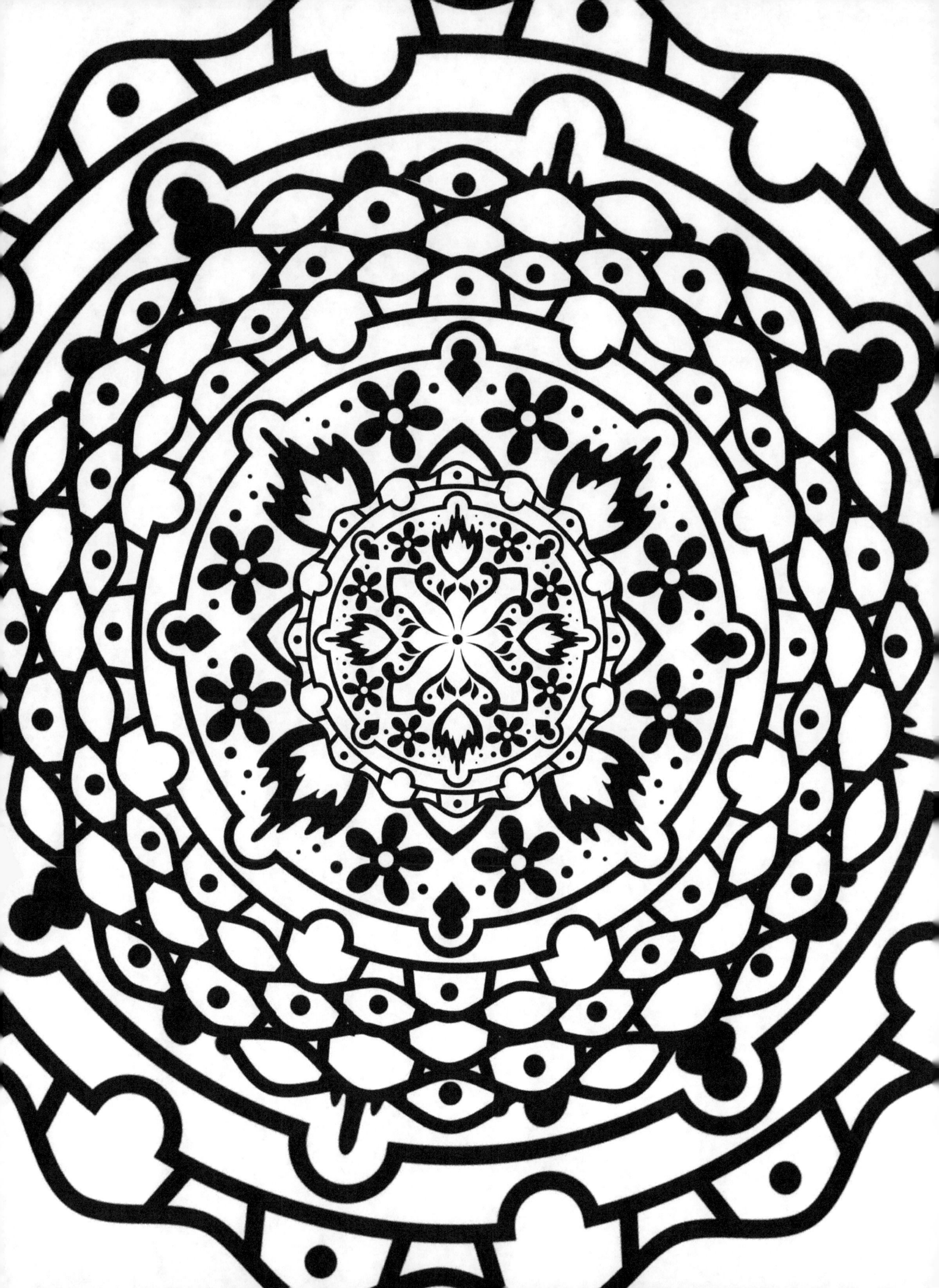

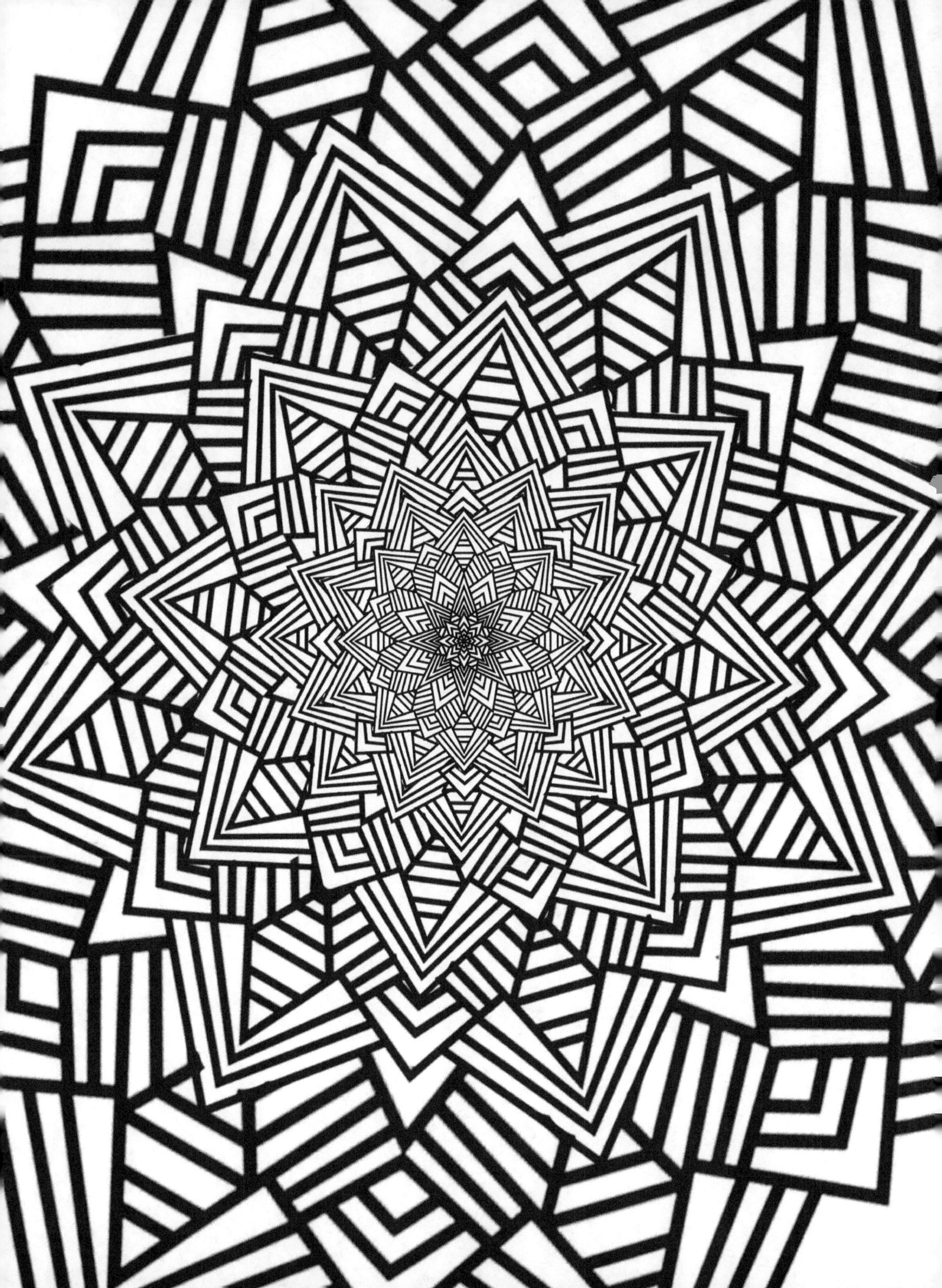

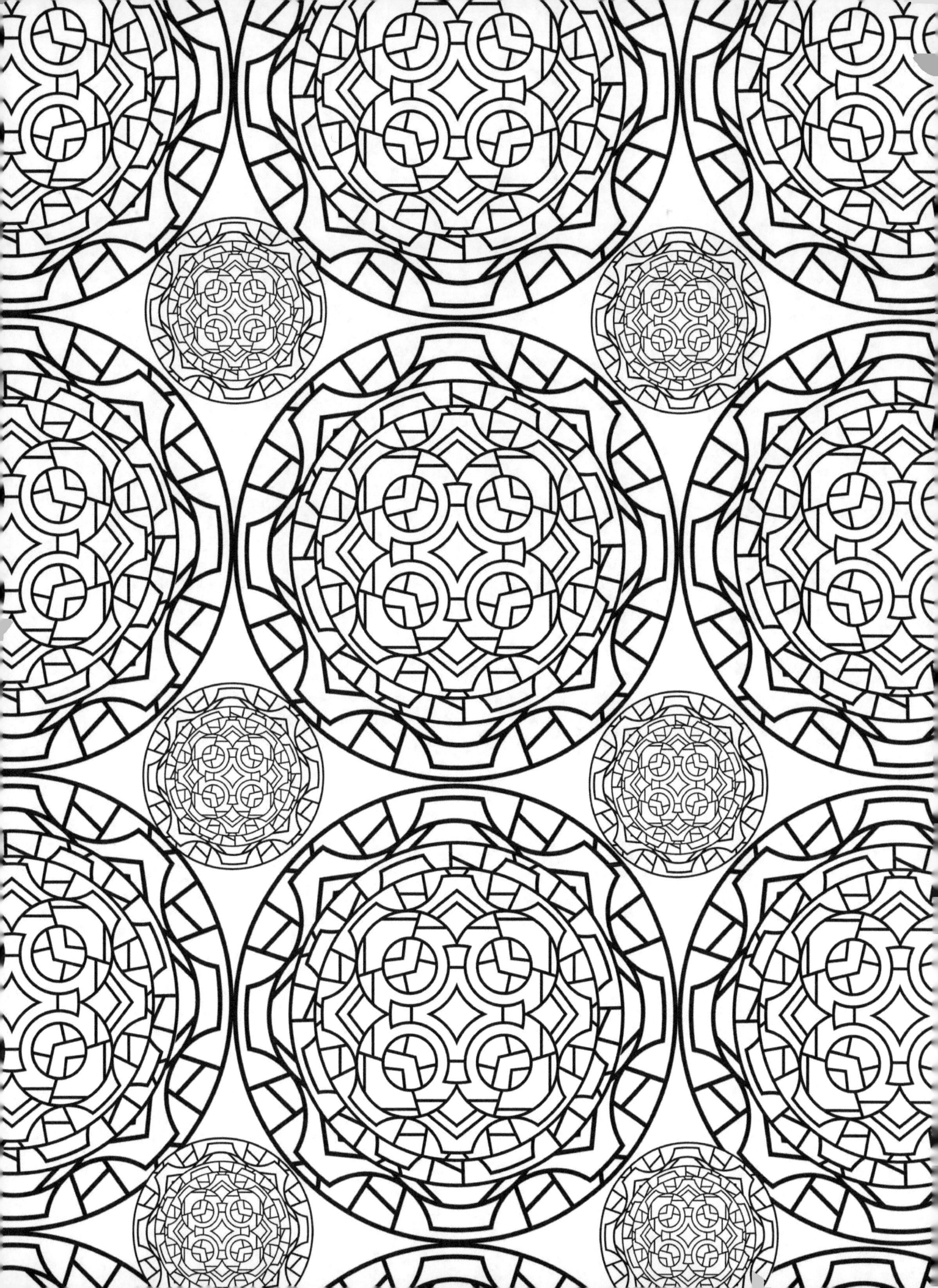

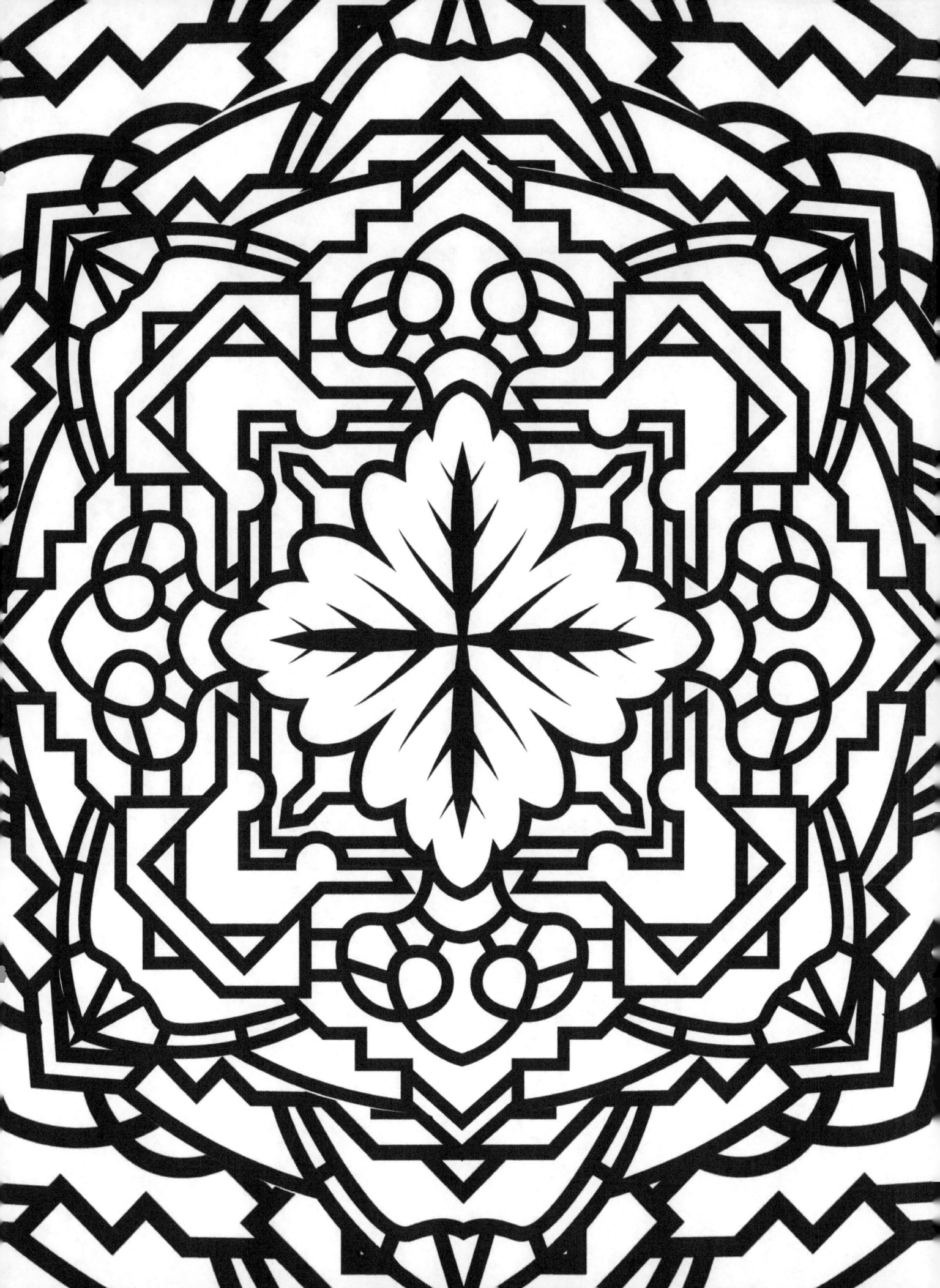

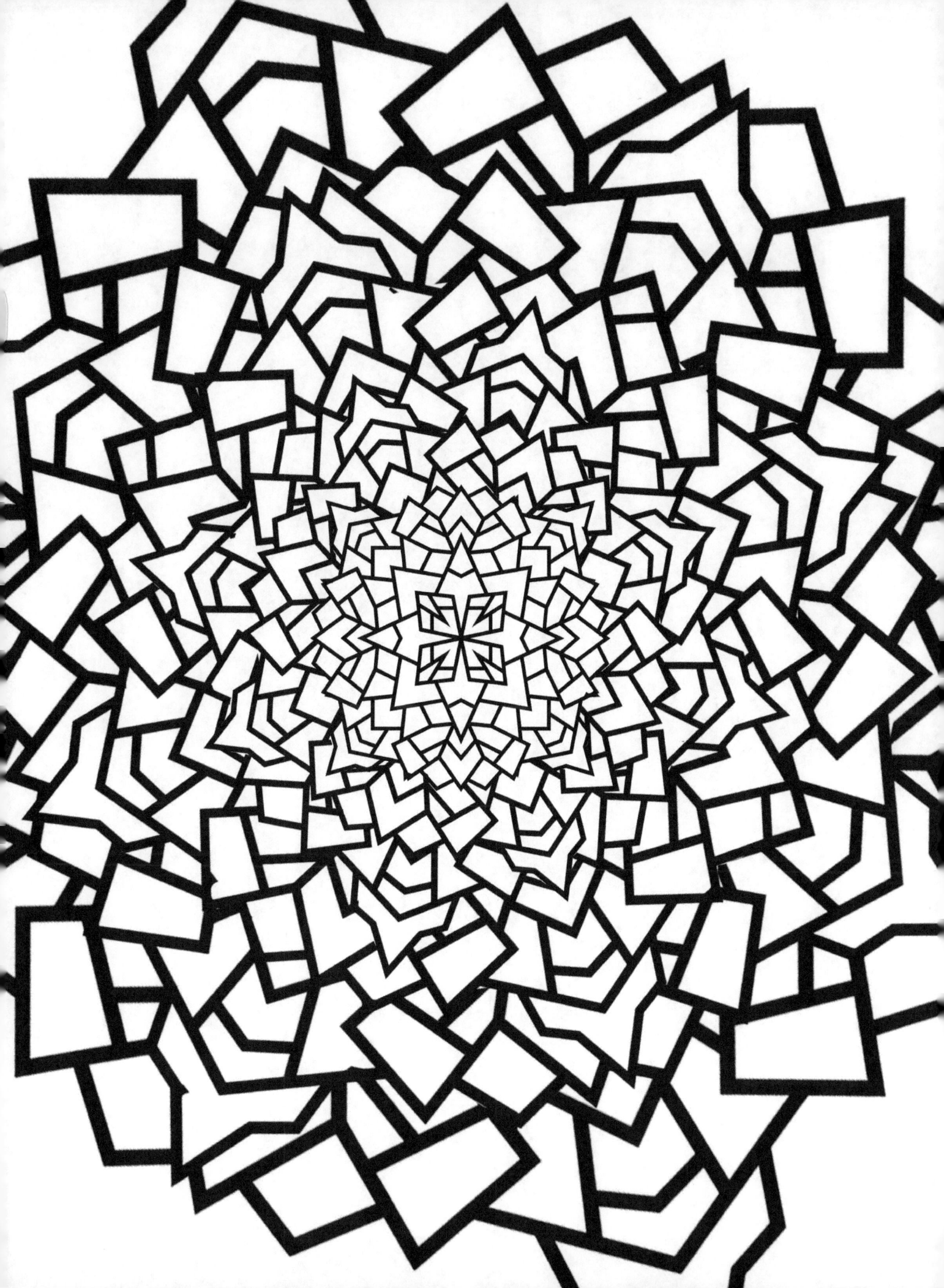

www.ingramcontent.com/pod-product-compliance
Lightning Source LLC
Chambersburg PA
CBHW080720190526
45169CB00006B/2457